BRUSHSTROKES

STYLES AND TECHNIQUES OF CHINESE PAINTING

SO KAM NG

ASIAN ART MUSEUM OF SAN FRANCISCO

The exhibition *Brushstrokes: Styles and Techniques of Chinese Painting* has been made possible by grants from the Bernard Osher Foundation, the California Arts Council, a state agency, and the National Endowment for the Arts, a federal agency.

Asian Art Museum of San Francisco
October 14, 1992–January 3, 1993

Santa Barbara Museum of Art
February 13–April 25, 1993

Distributed by University of Washington Press, Seattle and London
ISBN 0-295-97239-4

Cover: Chang Dai-chien, *White Lotus* (detail), dated 1948 (no. 22)
Back cover: Figures in a landscape after a Qiu Ying painting, Qing dynasty, 18th century (no. 62)

Photography: Kaz Tsuruta
Illustration: Lam-Po Leong
Editing: Lorna Price
Design and Production: Marquand Books, Inc.

Printed and bound in Japan

FOREWORD

The marks of a Chinese character upon bright white paper are as sharp, clear, and beautiful as the sight of a sailboat on a misty bay. A brush of lacquer-black ink down a page seems as inevitable, as engagingly pure, as a Mozart aria.

Whether in calligraphy or painting, the Asian artist gives us moments of perfection on paper that represent the high attainment of hard work, creativity, and observation. Unlike painting in oils, these cannot be altered by second thoughts. Refined from the beginning, the art is spontaneous in effect, never labored. One can even sense from the strokes the emotion of the artist. Aside from the sheer joy of displaying great works of Asian art, the museum presents this exhibition in the hope that the visitor will observe the nearly infinite variety and strength of the discipline and art of the brush.

I express thanks to Associate Curator So Kam Ng for her efforts in producing this exhibition and catalogue. She worked ceaselessly to bring together the disparate elements of a complicated project. I also thank Paul Perrot, Director, the Santa Barbara Museum of Art, who worked with us in extending the reach of the exhibition to southern California. He was joined in Santa Barbara by Curator Susan Tai in enthusiastic support for the exhibition.

At the Asian Art Museum, Research Assistants Athena Yee and Kathleen Scott did much to advance the exhibition and catalogue. Libby Ingalls, Curatorial Assistant, worked throughout the development period of *Brushstrokes*, as did Exhibition Coordinator Hal Fisher, whose timely efforts to secure funding met with total success. Finally, may I also thank the members of our Exhibitions Committee, so well led by Mrs. Hart Spiegel, who early saw the importance of this program.

This exhibition has been made possible by grants from the Bernard Osher Foundation, the California Arts Council, and the National Endowment for the Arts. We are grateful to each for supporting this institution in our continuing effort to bring great Asian art exhibitions to a growing audience.

Rand Castile
Director, Asian Art Museum

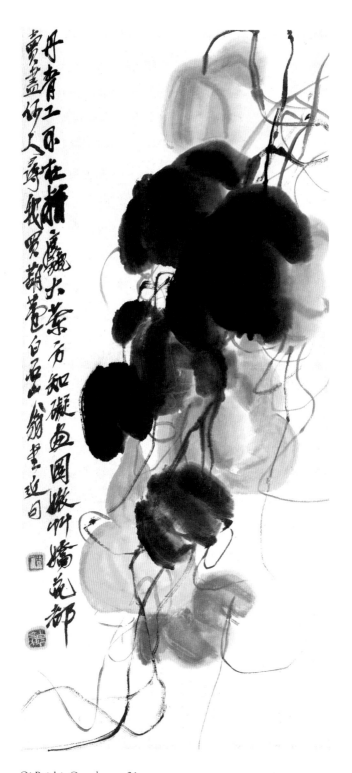

Qi Baishi, *Gourds*, no. 21

BRUSHSTROKES: STYLES AND TECHNIQUES OF CHINESE PAINTING

Painting and calligraphy, supreme art forms in China, are dependent upon the expressive potential of the brush. The dynamic quality of its rhythmic line enlivens the surfaces of many early artifacts. Artists in each successive era expanded their technical repertoire with the brush as they dealt with developing subject matter and changing attitudes toward the function of pictorial representation. As painting evolved from a descriptive art to take on a more personal and reflective role, a preference emerged for brushwork that incorporated greater nuance and inflection. A painter could convey grace and elegance with a fine, sinuous line, while a vibrating line of varying width created tension and unrest. Adopting stylistic as well as theoretical principles from calligraphy, painting became a means of self-expression, of mirroring the mind and inner character of the artist.

Specific brushwork and stylistic conventions were developed for depicting figures, birds, flowers, animals, and landscape. These genres formed a corpus of brush techniques perpetuated by artists learning and drawing inspiration from the past. Avid archivists, the Chinese documented significant stylistic developments with textual descriptions and illustrative examples; they had an interest in establishing artistic lineage as well as in classifying techniques. Their activities included the compilation of painting methods, especially on subjects with symbolic meaning for the educated elite, such as manuals on bamboo, cymbidiums, chrysanthemums, and prunus, plants representing the virtues of a gentleman. Important works of art were preserved in the form of copies. Calligraphy in particular was engraved on stones, and ink impressions taken from these carvings were collected and treasured.

This aesthetic tradition exerted considerable influence on other East Asian cultures, especially Japan and Korea. Japan is an important repository of Chinese art and culture. Since the first contact with China, Japan actively maintained ties with the mainland. Prevailing styles and trends in China supplied impetus for new artistic development. The brush became an essential element of traditional Japanese society. Mastering technical and philosophical ideas that had evolved in China, Japanese painters interpreted these techniques, motifs, and principles according to their own sense of aesthetics and design.

Chinese decorative arts were also affected by stylistic elements inherent to painting. The most obvious are ceramics and lacquers, on which the brush is employed to apply designs. The desire to imitate

painting, however, extends beyond works that involve the brush. Some pictorially decorated textiles give the illusion of brush-painted images. Carving is another area with direct correlations to painting and calligraphy; in some cases, surface treatment is dictated by impressions of the brush rather than dynamics of the knife.

The unique character of Chinese painting is inseparable from its materials. Although the later style of ink painting associated with the scholar's leisurely pursuit focuses on brush, ink, paper, and ink stone, the so-called Four Treasures, color pigments have also played an important role in painting since early works and continue to be used. Most bird and flower paintings, for example, depend on color, and specific techniques have been developed for this genre. The following explanation of properties of the brush, pigments, and ink introduces the basic materials of Chinese painting.

THE BRUSH

The brush is a versatile instrument with a three-thousand-year history of development from a simple tool to a highly expressive implement. Bristles of early brushes consisted of grass roots, crushed bamboo, or wood. The predecessor of the pointed-tip brush was conceived during the Qin dynasty (221–206 B.C.), when several types of animal hair selected for specific softness or stiffness were bundled together and attached to a handle.

The brush today is composed of three major sections, each with hair spaced and cut in different lengths. The center, a long inner core, is surrounded by a section of shorter hairs. Covering both of these is an outermost layer that extends from base to tip, forming a point at the end. The short mid-section creates a space between the inner and outer ones, a kind of reservoir that takes up and holds the ink or pigment. This construction assures that the brush glides smoothly across the painting surface, responding to the hand's pressure and speed while maintaining a steady flow of ink for extended brush movements.

Brushes are made from hair and fur of different animals—rabbit, goat, sheep, wolf, fox, horse, weasel, and sable. These hairs vary in flexibility to produce a variety of lines and textures; stiff mouse-whiskers were especially popular with calligraphers. Soft and flexible goat hair holds water well and is suited for applying the subtle gradation of washes. Wolf and deer hairs, harder and more springy, allow for greater fluctuation in the thickening and thinning of a line. The quality of the hair also differs with its location on the animal's coat, the animal's habitat, and the season during which the hair is collected. The shape and size of the brush determines the type of line or impression it makes. Calligraphers and painters preferred specific brushes whose character contributed to their unique brush style. Ming

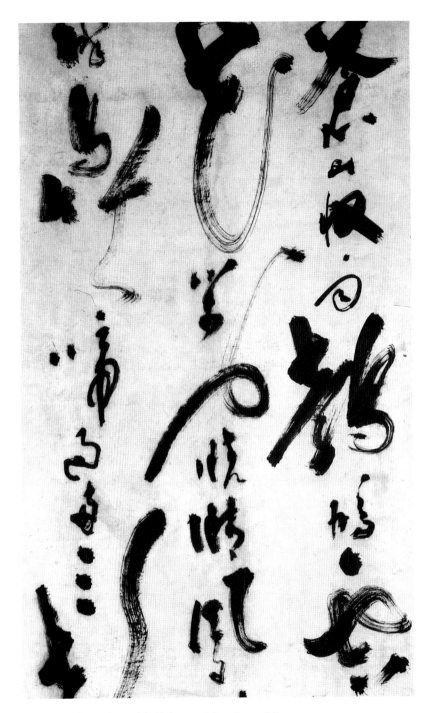

Chen Xianzhang, *Song of the Fisherman* (detail), no. 27

calligrapher Chen Xianzhang (1428–1500), for example, favored a stiff, worn-out brush whose hair separated under pressure, leaving the dramatic streaks of white space known as flying-white (no. 27).

COLOR

Another name for painting in Chinese is *danqing*, literally "red and blue." A skilled painter might be referred to as a master of the reds and blues, a metaphor that indicates the importance of color in Chinese painting, especially before the Tang dynasty (618–906). Even as early as the Zhou dynasty (1100–221 B.C.), the painting of pictures was defined as a matter of blending the five colors—red, yellow, and blue (familiar in the West as primary colors) plus white and black. The *Zhouli* (Rituals of Zhou), compiled during the Han dynasty (206 B.C.– A.D. 220), mentions five types of appointed officials in charge of painting in color. The fourth of the Six Principles of Xie He (act. 500), generally accepted as the basis for Chinese painting theory, advocates the application of colors according to the form or nature of the subject. Very few Tang and pre-Tang painting examples on paper and silk survive; most that do were recovered from tombs, ancestral shrines, and Buddhist caves.[1] Most of these early paintings are spectacular in scale, with bright, intense colors.

Traditional Chinese painting colors derive from mineral or vegetal pigments. Early artifacts reveal an interest in embellishing everyday objects with attractive patterns and colors. Traces of red remain on implements used by the Upper Cave Man at Zhoukoudian.[2] Neolithic painted pottery employed chalk (white), red ochre, charcoal (black), and yellow ochre. Some are decorated with bold geometrical designs and others with free-flowing patterns, precursors to later developments in brush painting. Marks in red and black pigment on the oracle bones of the Shang dynasty (ca. 1700–1100 B.C.) constitute the earliest records of Chinese writing.

PIGMENTS

Some masters have preferred their own methods for preparing pigments, but in general, preparation involves separating the colors into different shades ranging from full saturation to light washes. Mineral pigments are first washed, ground, and slaked in a solution to which liquid glue is added. Glue is the essential ingredient that binds the pigment to the painting surface; it is also important in ink making. After settling, the clearer, lighter portion of finely ground pigments can be separated from the darker, coarser, heavy particles that sink to the bottom. That bottom layer is then reground, and the solution is again left to settle, producing a middle layer of intermediate hue and saturation. The different grades of pigments are then dried and stored.

Pigments derived from plants require washing or filtering to remove impurities. Some grinding may be necessary, but for most boiling or soaking suffices. The pigments are then slaked in solution several times to settle out in layers of different saturation, as for mineral pigments.

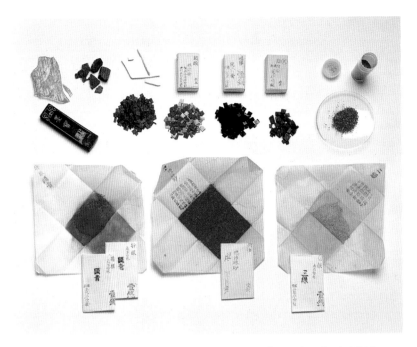

LEFT TO RIGHT: *Top row:* Animal-hide glue, rattan yellow, white lead. *Middle row:* Ink stick; ochre, cinnabar, indigo, rouge. The artist adds water to dissolve these little squares for painting; they already contain glue and produce transparent colors. The cinnabar in the glass dish and opened bottle is a coarser, darker grade which requires some preparation. *Bottom row:* Azurite, cinnabar, malachite. These opaque, powdered pigments require some grinding and the addition of a glue solution before use.

INK

Ink became the dominant medium when painting came under the influence of the literati ideals embraced by the educated scholar-gentry of later periods, which encouraged spontaneous expression and the painter's amateur (non-professional) status. At this time the decorative appeal of colors and skilled brushwork became associated with professional artists who sold their work for profit, a concept considered vulgar by literate gentlemen whose aspirations and motives as gifted painters excluded financial gain.

In traditional Chinese color theory, black is considered to contain all five basic colors. Capable of an infinite range of subtle tones and shades, monochrome ink can convey myriad moods and textures in a painting. Ink is a permanent and unfading medium. Once applied to the painting surface, it will not spread or bleed; after drying, lines, texture strokes, and layered washes cannot be diluted or dissolved by additional applications of ink, color, or water. This is important because the traditional method of mounting a picture involves some form of soaking or wetting the paper or silk on which it is painted.

Ink making, an art in itself, requires a delicate balance of selected soot, animal glue, and different combinations of secondary ingredients.

Good glue or sizing can enhance the ink's color and richness. Made from properly aged and prepared animal hide, tendon tissue, and horn, a high-quality glue should be light, clear, and free of organic impurities. A sixth-century recipe also calls for the addition of drops of egg white, powdered pearl, and musk.[3]

Great care is exercised in preparing and mixing all the materials to obtain a superior quality of ink. Numerous combinations of secondary ingredients have been established through time; some inks require twenty ingredients and include unusual materials—pig's gall, oxhorn marrow, Chinese honey locust, camphor, powdered jade, black soybeans. The goal is to produce an ink block that will not crack or change shape and which possesses a special fragrance and gloss when ground to make liquid ink. Some scholars tried making their own ink; the poet Su Dongpo (1036–1101) almost burned down his house during one attempt.

The best inks are made from pine soot, oil-soot lampblack (from tung oil), or lacquer soot, usually produced in a kiln. The "body soot" closest to the fire is of inferior quality; the "head soot" or top soot, located farthest from the fire, is the best. The middle grade, "neck soot," is collected from the center. Mixed with appropriate amounts of liquid glue and other ingredients, this refined carbon was molded into sticks or cakes of various shapes and sizes. Ink sticks of high quality were regarded as treasured objects and were often decorated with writings and pictorial designs; their patterns were carved into the ink stick molds. Colors, gold, and silver sometimes provided additional embellishments. Some of these designs were compiled into books; the most famous are the *Fangshi mopu* (Fang's Ink Manual), published in 1588, and the *Chengshi moyuan* (Cheng's Ink Manual), completed during the Wanli period in 1606. They include illustrations from well-known painters, among them Ding Yunpeng (1547–ca. 1621; p. 19) and his follower Wu Tingyu (act. seventeeth century).

BRUSHWORK TECHNIQUES

Chinese painting is a matter of manipulating brush and ink to express forms and emotions. In directing the brush, the basic methods are the conforming brush (*shunbi*) and the contrary or counter brush (*nibi*). In *shunbi*, the brush tip glides more easily over the surface and produces a smooth, elegant line. In *nibi*, resistance from the paper or silk causes the hairs to gather and separate, and the stroke has a harder and coarser feel. Control of speed and pressure is important. A line's rhythmic quality is achieved through the dynamics of moving and halting, pressing and lifting, and the shifting and changing of directions. The gnarled stem of Xue Wu's prunus (no. 18) is done in *nibi*, with the brush placed at an angle to the paper. The stroke starts from the middle; at the thickest portion of the line, the brush is being pushed downward, creating

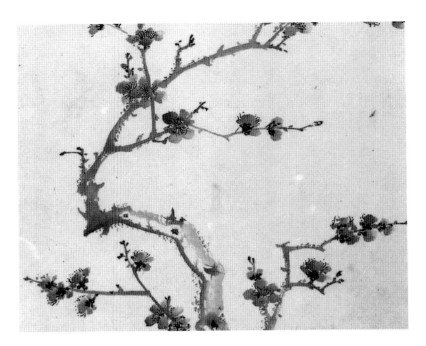

Xue Wu, *Ink Flowers* (detail), no. 18

friction with the paper. At each angle where the brush turns there is a pause or halt. The thinned line indicates a lifting of the brush; a thicker line indicates pressure on it. New shoots bearing delicate blossoms are done with a conforming brush held upright, its tip pulled rather than pushed.

LINES

The most fundamental element in ink painting is the line, which defines form and suggests movement. *Baimiao* is a technique of pure outline drawing for works done entirely in lines, without colors, shading, or wash. There is a long tradition of figure and flower paintings in this manner. Early Chinese figure painting is associated with the unmodulated brush whereby the dynamic quality of the brushstroke is suppressed, but artists could nonetheless invoke rhythm, tension, and volume with even and precise lines. Chinese writers often contrast the linear styles of Gu Kaizhi and Wu Daozi to illustrate the descriptive potentials of the simple line. The fine, graceful style of Gu Kaizhi (ca. 344–406) suggests linear movement through fluttering ribbons, rounded skirts, and fluid garment lines. Although thin and light, Gu's lines possess a great deal of tensile strength and, according to the Chinese, resemble "strands of thread emitted by the silkworm." Wu Daozi (ca. 689–ca. 758) of the Tang dynasty used taut, curving lines "like copper wires" to define muscles and drapery folds. His figures are said to embody the solidity and weight of sculpture.

THE EIGHTEEN OUTLINES OF WANG KEYU

Wang Keyu (1587–1645), art critic and historian of the Ming dynasty, classified eighteen linear methods for depicting garments. This list was published in Wang's collection of colophons and commentaries on calligraphy painting entitled *Shanhu wang* (Coral Net, 1643), and was widely adopted as a guide to basic linear techniques for figure painting.

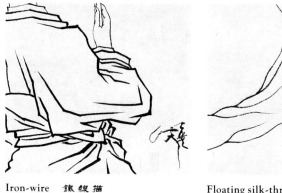

Iron-wire　鐵線描

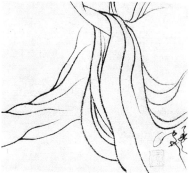

Floating silk-thread　高古游絲描

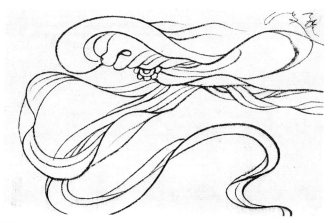

Floating-cloud or running-water　行雲流水描

Iron-wire lines: Long, narrow, rigid strokes with sharp angles resembling chisel cuts in stone; done with a vertical brush and even pressure.

Floating silk-thread lines: Extremely fine but strong lines that seem to float without breaking and resemble the kind of thread spun by the silkworm; done with the tip of a fine brush held vertically.

Floating-cloud (or running-water) lines: Even, carefully controlled lines seeming to describe the figure in a single, free-flowing line; very popular for depicting fluttering draperies.

Cao Puxing's garment lines: Lines resembling rippling water; done with a pointed brush tip; used to depict dense parallel drapery folds. Cao Puxing was active during the Wu kingdom (222–80 B.C.); later writers refer to his style of depicting drapery as clinging to figures like wet clothes: "Cao's garments come out of the water."

Lute-string lines: Long, thin lines conveying dignity and calm; drawn evenly and smoothly with a vertical brush.

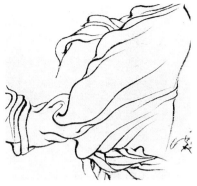

Nail-head rat-tail　釘頭鼠尾描

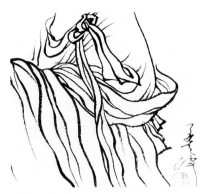

Willow-leaf　柳葉描

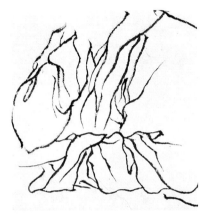

Rippled-water　戰筆水紋描

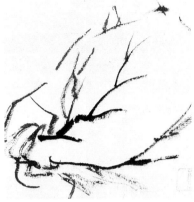

Lines of fewer strokes　減筆描

Earthworm lines: Not commonly used; an even line with rounded ends that hide the mark of the brush tip. Writers disagree as to its appearance and execution.

Nail-head rat-tail lines: Long, tapering lines beginning with a strong dot and tapering to a fine point. **Driven-stake lines** are similar but done with a blunt brush applied swiftly at an oblique angle.

Willow-leaf lines: Tapered at each end and wider in the middle, they have a gentle, supple feeling. **Bamboo-leaf lines** are similar but wider and thicker, done with a slanted brush.

Date-stone lines: A series of connected dots fine at the ends, thicker in the middle; done with the fine point of a large brush. **Olive-stone lines** are similar to date-stone, but the thick part is longer.

Rippled-water lines: Done with a quivering brush held upright.

Wasp-body lines: Varies from thick to thin from frequent but gradual pressure on the brush. Some writers identify it as the cymbidium-leaf line, drawn with a gentle, curving movement.

Broken-reed lines: Long, stiff, and coarse with sudden direction changes.

Firewood lines: Coarse, stiff lines; done with a large, stiff, slanted brush.

Lines of fewer strokes: A bold, vigorous, abstract line; often the entire garment is rendered in a few zigzag strokes. A style associated with Ma Yuan (act. 1190–1225) and Liang Kai (act. early thirteenth century).

Double lines: Drawn lightly with thin ink, then retraced with heavy ink to give depth and roundness. Both lines remain visible, side by side or overlapping, unlike sketching, where the second line covers the first.

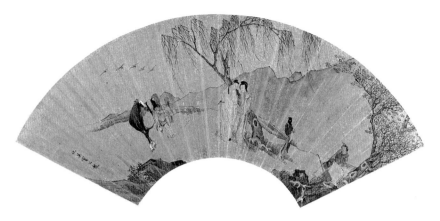

Qiu Ying, *Parting under a Willow Tree*, no. 13

Stiff, angular strokes executed in the iron-wire method are used here even in land-scape and trees. The servants on either side of the central figures are executed in hard, sharp lines. The lines describing the lovers become finer and softer, with slight curves. The illustrated scene is from *Tale of the Western Chamber*, a story by Yuan Zhen (779–831) which was made into a play by Wang Shifu during the Ming dynasty (late thirteenth to early fourteenth century). The illustration of vernacular litera-ture and popular drama, particularly in the form of woodcuts, was prevalent during the Ming dynasty.

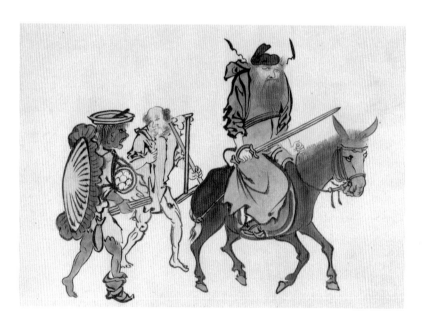

Pu Ru, *Zhong Kui (the Demon Queller) on a Mule* (detail), no. 15

The artist employed extremely various brushwork and frequently changed its direc-tion. The nail-head rat-tail line is clearly present, particularly in the rendering of garment folds. Sister arts that share the same materials, painting and calligraphy often reinforce each other in meaning and in form. The vigor and energy conveyed in these strokes point up Zhong Kui's role and power as Demon Queller, or exorcist of ghosts, demons, and evil spirits.

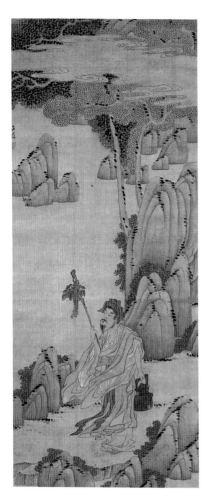

Chen Hongshou, *Ruan Xiu in a Land-scape*, no. 14

A fluid, rounded brushwork character-izes this painting. The drapery appears to be one continuous line enveloping Ruan Xiu, who exhibits hardly any sub-stance or weight. Resembling "floating clouds and running water," the lines carry the figure forward, creating move-ment in a strangely still setting. Above, swirling clouds echo the rhythm and forms of the garment. The eccentric Ruan Xiu, known as a toper, carries his wine pot and a staff or walking stick with strings of coins to replenish his supply at the local tavern. The awkward tilt of his head, downcast eyes, and tottering pos-ture suggest that he is perhaps already drunk.

Wang Keyu's list is by no means exhaustive. Some lines are rarely seen; some are so similar that it is difficult for anyone unaccustomed to using the brush to discern their differences. Even practicing artists are not familiar with the more obscure lines. These outline methods have been divided into three basic groups according to how the brush is used. In the first group, a threadlike line, such as the iron-wire and lute-string, is made with a slow-moving, vertical brush, with even pressure and little variation. Lines of the second group, like the willow-leaf, fluctuate distinctly from thick to thin within the stroke and require a fast-moving brush and constant variation, with additional pressure in mid-line. The third group requires swift movement, often with the brush held at an angle, rubbing and pressing against the surface; generally more pressure is applied to one end of the stroke. The bamboo-leaf line belongs in this group.

GONGBI STYLE: THE USE OF COLOR

Color is applied in essentially two ways, heavy or light; both could be used in the same painting. Heavy color involves the application of numerous layers of paint to achieve opacity. To stabilize and fix the thick coats of pigments, clear sizing or alum is applied between every two or three color layers to obtain smooth and even shades as well as to prevent cracks and flaking later, as a scroll painting might normally be rolled and unrolled numerous times. Sometimes underpainting is employed to intensify or highlight a certain color, particularly for flesh tones and areas of white. Lightly applied color retains a kind of transparency; the application of pigment generally alternates with washes of clear water.

The use of colors is often associated with the *gongbi* style of painting, which requires a careful and precise application of paint unmodulated by evidence of the brush's passage, and with meticulous attention to details, forms, and standards. In the outline-and-fill method, lines delineate the contour shape, which is then filled with color. Great care is taken to paint close to the lines without obscuring them. In the outline-and-draw method, the color covers the drawing, and the lines have to be redrawn. In this way the sketch does not have to be in black nor do the lines or details that are to be redrawn over the infilled painted areas. Brushwork in these techniques becomes evident in these lines rather than in the opaque and unmodulated areas of infill. Sometimes fine lines in gold or silver are used to enhance the beauty and precious quality of the picture.

In a workshop situation, such as the decoration of a palace, temple, or tomb, the master first sketched out the design in ink. His assistants or apprentices then performed the laborious task of filling in the colors. Finally, the master completed the picture by retracing the lines and adding final details. Many religious paintings were done in this manner (see no. 29).

During the Tang dynasty, a style of landscape with intense azurite blue and malachite green evolved. Its impact was so great that this color scheme continued to be used, although in later works texture strokes, graduated hues, and ink washes were incorporated into the picture (Ding Yunpeng, p. 19, not in exhibition). Another form, the so-called gold-and-green landscape, employs gold outlines and underpainting of red or yellow ochre, applied to enhance the blue and green areas.

Color, naturally, is very important in bird and flower painting. An example of *gongbi*-style flower painting is Yun Bing's *Lotus* (no. 20). There is no ink outline, but the silhouette forms a hard contour, defining the shapes. The lotus flowers have white underpainting to bring out their pristine, fresh quality. Starting from the edge of each petal, layers of pigment are laid on slowly. The hue gets darker with each successive

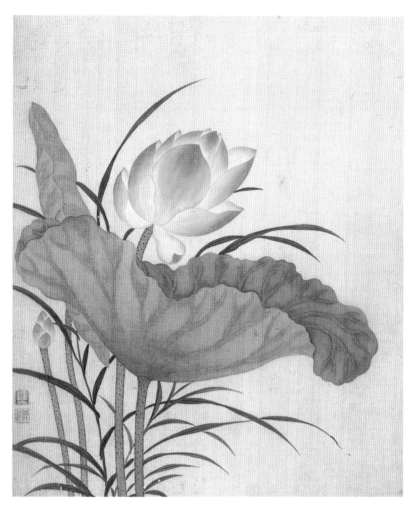

Yun Bing, *Lotus*, from an album of twelve flower paintings, no. 20

coat. To blend the color more evenly, two brushes are used alternately, the first loaded with pigment, the second with water. Each stroke of color is followed by one with water. Leaves and stems do not have an undercoat. They are also done in the paint-and-water method, but with fewer applications of paint.

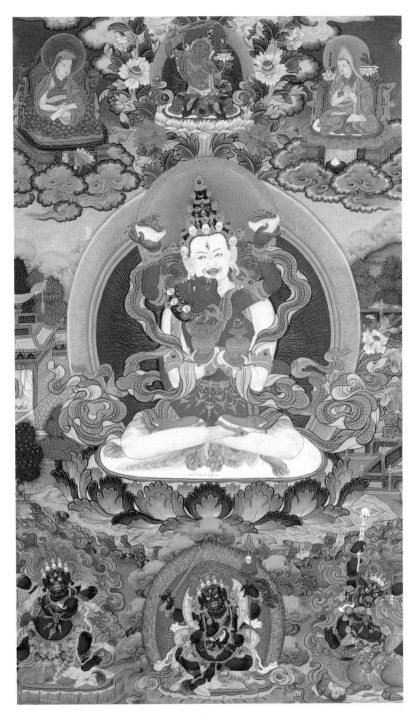

Sitasamvara (detail), Sino-Tibetan *thangka*, no. 29

Sitasamvara is the peaceful form of Samvara, a powerful deity of Esoteric Buddhism. He is portrayed as a white figure seated on a tiger skin holding his partner Vajravarahi, who is painted red to symbolize passion. The lines of the painting, done in strong, opaque colors, are fluid and graceful. Detail work is in gold.

Ding Yunpeng, *Landscape in the Style of Huang Jucai* (detail), B74 D2
(not in exhibition)

Artists often modeled their work after the manner of another master as a way of
expressing admiration or invoking certain images. This painting is done in a deliber-
ately archaic manner characterized by the heavy use of blue and green colors.

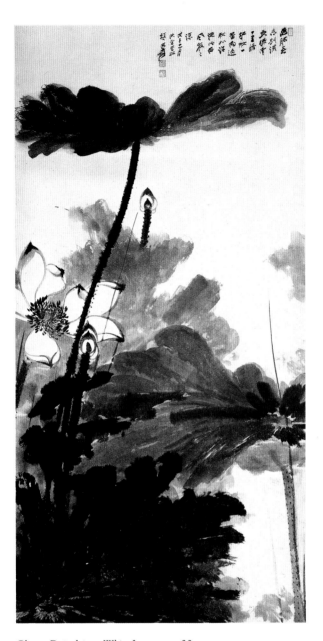

Chang Dai-chien, *White Lotus*, no. 22

The magnificent lotus plant embodies rich symbolic meanings. Since its seed pod is conspicuous even in the bud stage, it represents the Chinese wish for many children, especially sons. The flower is also a symbol of purity because it grows in mud but is unsoiled. Chang describes the various textures of the flower and leaves in different shades of ink. Buds, petals, and pod are depicted with a controlled brush and fluid lines. The stems are in dark, attenuated lines expressing stiffness and inner strength. Chang used splashed- and broken-ink techniques for the leaves. A layering of broad washes expresses their different stages of growth. The young, tender, tightly curled leaves are dark and dense; mature leaves, in medium to light shades, are spread out and rise high above the water; old, withered leaves show ragged edges, insect-eaten holes, and tears along the veins.

XIEYI STYLE: INK AND WASH

Colors dominated Chinese paintings until the Tang dynasty, when ink painting associated with the style of the poet Wang Wei (699–761?) came to be identified with the cultivated mind of the scholar-gentleman, the literati who had retreated from public service to write poetry, paint, and meditate. Su Dongpo, commenting on Wang Wei's art, said that there is "painting in the poetry, and poetry in the painting." Thus painting was elevated to the position of literary art, a pursuit worthy of a gentleman, one of the Four Accomplishments (the other three were the playing of the *qin*, chess, and the art of calligraphy). Painting, together with poetry and calligraphy, formed the Three Perfections. In this way, painting functioned as a medium of personal expression, revealing the inner character of the artist.

Xieyi is a style of free and spontaneous painting, primarily in ink, sometimes with light color tints. Favored by the literati for its simplicity, which supported their amateur-status ideal, *xieyi* expanded the dynamic use of the brush, bringing painting even closer to the aesthetic approach of calligraphy. The goal was not so much to capture outward appearance, which literati painters relegated to the domain of craftsmen and professional artists, but the subject's spirit or essence.

As mentioned above, the Chinese believe that black, the color of ink, embodies the chromatic spectrum and that one comes to perceive colors in the various ink tones and hues. Su Dongpo was once criticized for painting bamboo with red ink, which did not represent the natural aspect of the plant. When asked what color he should have used, Su's critic replied, "Black, of course."

Literati artists exploring the expressive possibilities of ink engaged in what is called "ink play." Some of the most popular methods include splashed ink, broken ink, dry brush, flying-white (*feibai*), and layered ink. Splashed ink originated during the Tang dynasty. Texts relate that practitioners often performed this art in a state of intoxication, pouring and flinging ink onto the silk or paper with their brush, hair, hands, or some other spontaneous method, singing and dancing at the same time. Then, in a flash, with a few strokes of the brush they transformed these ink smears and puddles into images of rocks, clouds, mountains, and water.

The *xieyi* style also involves manipulation of ink or color tonalities. Choice of paper can determine the tonal effect. Zhou Zhimian's fan painting *Snowy Egret under a Tree by a River* (no. 23) is on sized paper. A solution of glue or alum was applied to its surface, which was further embellished with gold flecks (silk could also be sized). The ink wash on this type of surface was done with two brushes. The first brush applied the ink while a second, loaded with water, diffused the wash and blurred the otherwise hard edge. A sized surface does not immediately absorb ink, which allows time to apply the second stroke. This process

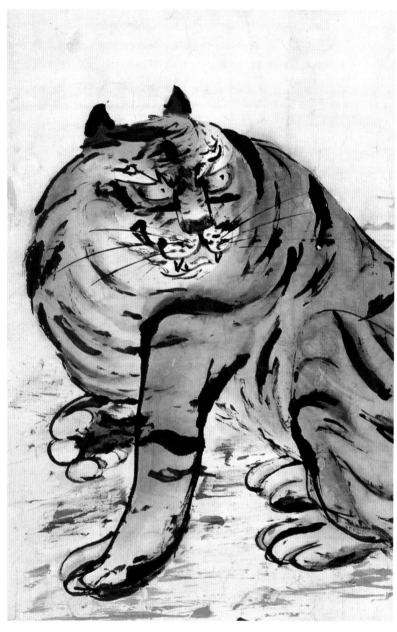

Gao Qipei, *Tiger* (detail), no. 24

Gao's *Tiger* is a finger painting, a technique deriving from the ink-flinging and smearing methods used in the Tang dynasty. Gao is known for his dynamic execution of figures, animals, and landscapes with fingers and hand. To draw lines, the artist would use his long fingernail as a quill. With hand palm-up, he could guide the strokes with the nail edge, tilting it to control the flow of ink. Wash was applied with fingers and hands.

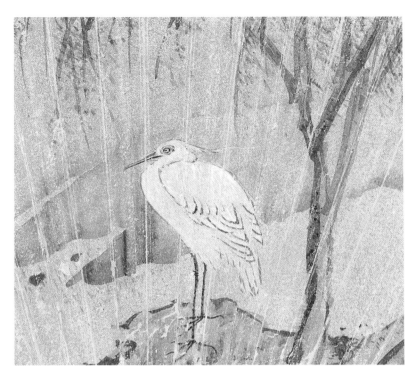

Zhou Zhimian, *Snowy Egret under a Tree by a River* (detail), no. 23

could be repeated several times to achieve the desired tonalities. Each application of ink and wash had to dry before continuing with the next. Zhou kept the outline defining the riverbank but used the water method to blend the ink on the other side, achieving a misty, receding atmosphere.

Huang Shen's *Geese among Reeds* (no. 25) is on unsized paper, which absorbs ink almost immediately, allowing no time for it to merge with subsequent strokes. Once dry, each stroke retains its distinctive form unaffected by any overlaid lines, strokes, or washes. The artist drew the geese and reeds first with diluted color and ink, then darker ink. Two techniques were employed for tinting the background. The grassy banks in front consist of several broad washes in different shades of black. Done in single strokes, they reveal traces of the brush. The wash suggesting water or distant sky was achieved by first wetting the paper with water, then applying ink. The wet paper allowed the ink to merge more evenly while also creating a soft, blurry contour.

Attributed to Huang Shen, *Geese among Reeds*, no. 25

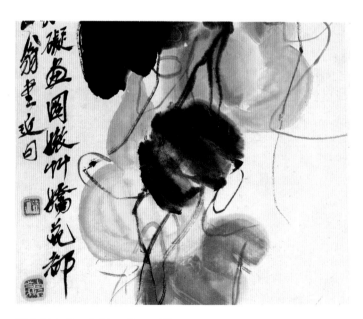

Qi Baishi, *Gourds* (detail), no. 21

"Boneless" means painting forms without outlines in colors or ink. To achieve different tones within a single stroke, the artist loads the brush with varied shades of ink or color, starting from light to dark. (If ink is combined with colors in this technique, it is always added last.) These gourds and leaves are done with broad, full strokes in the boneless style. The vines are executed in flying-white, a technique deriving from calligraphy. The brush has so little ink that the hairs separate, leaving streaks of white, unpainted space. The calligrapher or artist may deliberately cause the hair to separate by increasing the pressure applied to the brush.

LANDSCAPE PAINTING TECHNIQUES

Landscape painting became an independent genre during the Tang dynasty. Landscape, *shanshui hua*, embraces the Chinese perception of the universe, an innate love of nature, a respect for its mysterious forces, and the desire to be in harmony with its elements. The Chinese term literally means "picture of mountain and water." Both these landscape features appear together frequently, symbolic of the cosmic idea of opposites, *yin* and *yang*. A mountain, representing the male, is hard and unyielding, while water, perceived as soft and retiring, is associated with the female principle.

Rocks and mountains are the essential components of a landscape painting. The artist first outlines the basic composition with ink. He then applies texture strokes, the most distinctive feature in Chinese landscape painting. This method, *cun*, essentially uses lines to describe the shapes and characteristics of rock or mountain structures. Based on observation of nature, it embodies the creativity of past masters who developed techniques to depict various natural phenomena.

Specific artists are known for their particular styles of brushwork. The most commonly used *cun*, the hemp-fiber stroke linked with Five Dynasties artist Dong Yuan (ca. 900–962), is done with an upright brush held in a relaxed manner. The axe-cut stroke, attributed to Southern Song court painters Ma Yuan (act. 1190–1225) and Xia Gui (act. 1200–1230), is done quickly with the side of the brush, resulting in a ragged triangular form. The severed-band stroke associated with Yuan master Ni Zan (1301–1374) involves a change of the brush from an upright to an oblique position. Some texture strokes are in the form of Mi dots, associated with Mi Fu (1051–1107) and Mi Youran (1086–1165), which are applied in a wet, diffuse manner.

After the structural form of the rock or mountain has been defined, the artist distinguishes the light and dark areas through the layering of diluted ink or color washes. Many applications might be required to achieve a subtle gradation from light to dark. Dots, the final element, can serve numerous functions. They identify darker areas; suggest trees or lush vegetation on distant mountains, grasses or foliage in the foreground; or provide accents in the composition.

Tradition plays an important role in the culture and arts of China. Unlike the West, where imitation is stigmatized, in China the works and styles of ancient masters are honored by being passed down through copies. The Chinese made a clear distinction between different forms of copying. *Mu* means to make a duplicate by tracing or another method of transfer. *Lin* is to copy faithfully an original that is close at hand, but without resorting to tracing. *Fang* refers to a painting done in the manner or style of an earlier artist. As a free interpretation of a previous work, it is also a tribute to the original master.

Zhuang Jiongsheng, *Landscape* (detail), no. 9

The rendering of trees and leaves constitutes another important category of brush technique. Zhuang's handscroll employs some of the most common leaf forms executed in the dotting and outline method. Trees and foliage are usually the most conventionalized elements in later Chinese landscape painting. Foliage is placed on two sides of the main trunk, leaving it exposed. Many of the leaf forms, particularly those in outline, do not describe vegetation in a realistic sense, but are used to provide variations in texture and shape.

Song Xu's version of Wang Wei's eighth century Wangchuan picture is done after a copy by Wang Meng (1301–1385). The composition of the Wangchuan picture was eventually engraved. Ink rubbings from the engraving made it possible for later artists to study and copy what they assumed to be the style and work of Wang Wei. This approach led to the compilation of painting manuals; these encyclopedic volumes consisted of reproductions of past masters' works accompanied by explanations of their styles and detailed illustrations of conventionalized brushwork.

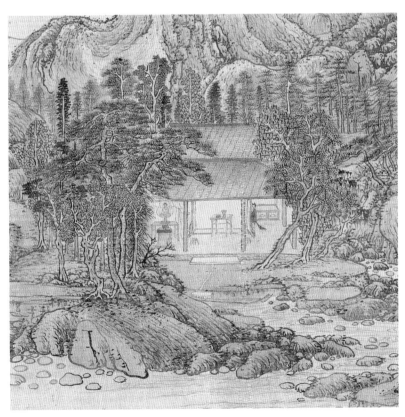

Song Xu, *Landscape after Wang Wei's "Wangchuan Picture"* (detail), no. 3

Song's landscape after Wang Wei's painting illustrates the Chinese concept of copying. The original, Wang's rendition of his mountain villa, no longer existed during Song's time. The Wangchuan scene, however, existed in numerous copies and formats because Wang was perceived by later artists and historians to be the founder of the literati tradition that represents the scholar's ideal as well as the concept of the virtue of leisurely retreat.

TEXTURE STROKES IN LANDSCAPES

Axe-cut strokes (large and small): Triangular strokes resembling cuts made by an axe; they are associated with Song artists Ma Yuan and Xia Gui. Done with a slanted brush. **Axe-splits:** Longer than axe-cut strokes; ridges are white rather than outlined in black.

Hemp-fiber strokes: Long, slightly wavy, relaxed strokes, most common of the *cun*. Done with an upright brush held in the center of the handle. **Short hemp-fiber strokes:** Done with the brush tip. **Confused hemp-fiber strokes:** Rougher and coarser, tending to be tangled.

Tangled hemp-stalk strokes (sometimes called tangled brushwood): Straighter, angular, irregularly crossed. **Cow's-hair strokes:** Similar to hemp-fiber with shorter and finer strokes suggesting smooth rock formations.

Cloud-head strokes: Curving strokes built up in shapes like cumulus clouds; associated with Guo Xi (act. 1068–1078). **Rolling-cloud strokes:** Long, curving strokes with a sweeping effect.

Devil's-face strokes: Extremely rough.

Large axe-cut　大斧劈皴

Small axe-cut　小斧劈皴

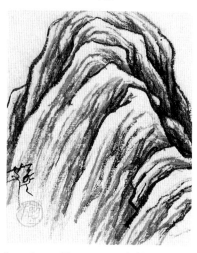

Long hemp-fiber　長披麻皴

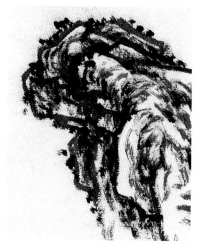

Short hemp-fiber　短披麻皴

Mi dot: Extremely wet, diffuse dots creating a blurry, atmospheric effect; associated with Mi Fu. Made by laying the brush sideways and parallel to the picture horizon. **Raindrop and sesame-seed dots:** Small, full dots.

Raveled-rope strokes: Each stroke retains a twist; done with a slanted brush.

Severed bands: Horizontal strokes with an abrupt downward ending, giving the effect of horizontal stratification. Done by dragging the tip of the vertical brush horizontally, then turning an angle with the brush slanted. Associated with Yuan master Ni Zan. **Bands dragged in mud:** Freer and more spontaneous, the general shape is applied in wash; before it dries, added strokes produce a less clearly defined effect. Done with a slanted brush.

Nails pulled from mud: Combine lines and dots. Sharp-headed dots are applied to broad, moist, hemp-fiber strokes before they are dry. **Nail-head strokes:** Emphasize and define contour and planes of rocks and mountains.

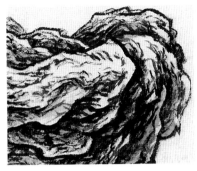

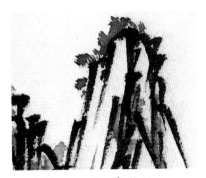

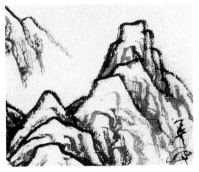

Tangled hemp-stalk　亂柴皴　　　　Cloud-head　雲頭皴

Mi dot　米點　　　　　　　　　　Raveled-rope　解索皴

Bands dragged in mud　拖泥帶水皴　　Nail-head　釘頭皴

A VOCABULARY OF DOTS

A variety of dots can be used to depict leaves. The following examples are taken from the *Mustard Seed Garden Painting Manual*. See also Zhuang Jiongsheng's *Landscape* (no. 9) on page 26 for a painting that employs many dot styles.

Pepper dots: Often used for cedar leaves.

Rat's-foot dots: Arranged fanwise in groups of four or five, with a white space at the center.

Chrysanthemum dots: Seven or eight medium-width strokes radiating in a full circle from a white center.

Jie dots: The individual strokes may be thin, thick, or overlaps of light and dark ink, but they resemble this character: 介.

Confused dots: Similar to Mi dots; wet oval strokes with blurred contours.

Even-headed dots: Short, fine, horizontal strokes, sometimes used to define mountain contours and suggest distant vegetation.

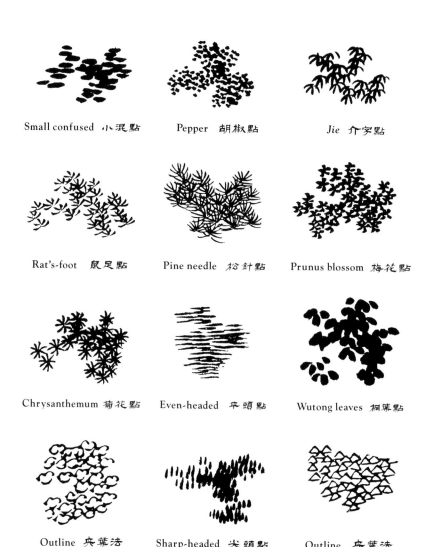

Small confused　小混點　　　Pepper　胡椒點　　　*Jie*　介字點

Rat's-foot　鼠足點　　　Pine needle　松針點　　　Prunus blossom　梅花點

Chrysanthemum　菊花點　　　Even-headed　平頭點　　　Wutong leaves　桐葉點

Outline　夾葉法　　　Sharp-headed　尖頭點　　　Outline　夾葉法

Methods for modeling solid, massive rocks and mountains are the most varied and numerous of brush techniques. Depiction of water, on the other hand, is one of the simplest elements in Chinese landscape painting. Water is often seen in the background and is rarely a prominent feature in the picture; its presence is suggested rather than depicted. Sometimes blank spaces represent bodies of water. A small boat or a solitary fisherman at the bank of a river or lake reinforces the water imagery. The artist might add a few wavy lines to describe ripples and more turbulent water. The treatment for waterfalls, cascades, and meandering streams is similar. The course of the water is defined only by the outline of shores or banks; the water itself is indicated by the unpainted surface of the paper. Sometimes small rocks, simple outlines, and light tinting are added to break up the void that indicates water and give it more definition. (See pp. 19, 23, 26, and 27.)

Clouds, mist, snow, and rain are also depicted by omission. Hook clouds, an outline form derived from the meticulous blue-and-green style, is done in a freer and looser manner. Otherwise, clouds and mist take the forms of breaks within and between solid masses. These breaks also serve to suggest infinite distance or space. Tinting the background with an ink wash and leaving white space above foliage give the impression of snow. In a snow landscape the top of a rock surface is white, while the underside is defined by texture strokes.

PAINTING MANUALS AND PRINTMAKING

During the Ming dynasty the art of woodblock printing and book production reached its height. In addition to the customary demand for the classics, philosophy, histories, prose, and poetry, a growing interest developed in vernacular literature, librettos, and painting manuals, in which pictorial images were an especially important element. By the late Ming dynasty, book publishers were competing for well-known artists to contribute illustrations. Ding Yunpeng (p. 19) and Chen Hongshou (no. 14) were particularly successful in collaborating with Ming woodcut artists who transferred their pictorial designs to prints. Their styles of *baimiao* (outline) drawing were especially suited for this medium.

Despite differences in technique and material, traditional Chinese woodblocks were closely related to and heavily influenced by painting. Woodblock designers and carvers tried to maintain as much as possible the impression of the brush. The style of their pictures was based upon prevalent trends in painting. Before the invention of multiple-block printing, successive colors were applied by hand to one master block or to the print.

The *Ten Bamboo Studio Manual of Painting,* the first of whose sixteen volumes was completed in 1619, marked a breakthrough in the art of woodblock printing, bringing it even closer, visually and methodically, to painting. The author-compiler, Hu Zhengyan (1584–1674), a skilled painter, also studied carving and the making of ink and paper. He was therefore able personally to supervise and inspect all aspects of the publication. Completed in 1633, the volumes covered the classical repertoire of subjects: famous calligraphy and painting of the past and present, bamboo, ink masterworks, rocks, birds and animals, flowering prunus, cymbidiums, and fruit. These prints were based on Hu's works as well as those of illustrious artists like Zhao Mengfu (1254–1322) of the Yuan dynasty, and Ming dynasty artists Shen Zhou (1427–1509), Wen Zhengming (1470–1559), Tang Yin (1470–1523), Lu Zhi (1496–1576), Chen Chun (1483–1544), Wu Pin (act. 1591–1626), Qiu Ying (ca. 1494–ca. 1552), and Mi Wanzhong (1570–1628). An educated man, Hu evidently belonged to the elite literary circles which included many of these scholars and artists, and he must have enlisted their participation in his endeavor.

A contemporary, praising the quality of Hu's prints in the *Ten Bamboo Studio Manual,* comments that the methods for applying ink texture and shading as well as the amount of color are so perfect that one could easily mistake them for a brush painting instead of a "carved picture." This comment illustrates the intent of these prints to imitate as much as possible the impression of actual brushwork. To achieve this effect, the process of multiple-block color printing using matching intaglio and relief-carved plates was developed. This publication

exerted considerable influence on printed albums of later times. The Japanese style of *ukiyo-e* (pictures of the floating world) is related to the *Ten Bamboo Studio Manual* in terms of block carving and printing techniques, although the aesthetic approach and subject matter are totally different.

The most influential painting manual for students of Chinese painting is the *Mustard Seed Garden Manual of Painting*. First published between 1679 and 1701, it has gone through more than twenty printings; the first lithographic version was produced in 1887–88 in Shanghai. Modern facsimiles have been produced from the various editions, including full and partial translations into other languages.

Unlike the *Ten Bamboo Studio Manual*, the *Mustard Seed Garden Manual* does not seem to have had a single publisher or author. Three brothers from the Wang family were primarily responsible for its illustrations and content. Wang Gai, the general editor, supervised the work for all three parts and was author and illustrator of Part I, landscape. The other brothers, Wang Shi and Wang Nie, specialists in bird and flower painting, assisted in preparing the art for Parts II and III, which deal with these subjects. Part II contains a book on each of the so-called Four Gentlemen—cymbidium, bamboo, flowering prunus, and chrysanthemum. The final section contains discussions and examples of flowering plants, grasses, insects, and birds. The original woodblock series was printed with colors and subtle ink tones. Later lithographic editions were reproduced only in black and white. These monochrome illustrations, however, strongly influenced Korean and Japanese artists, as well as later generations of Chinese painters.

CHINESE INFLUENCE ON JAPANESE PAINTING

Chinese-style painting, along with Buddhism, seems to have been introduced to Japan through Korea. In 552 the king of Paekche (Japanese: Kudara) in Korea presented a gilt bronze image of the Buddha to Emperor Kimmei of Japan, and the earliest surviving painting in Japan (ca. early seventh century) depicts a Buddhist theme. On the panels of the Tamamushi shrine in Hōryuji are narrative scenes from Jataka stories illustrating the past lives of the Buddha. The style of these lacquer-painted panels recalls the swirling movement, compositional elements, and decorative style found in paintings from cave sites at Dunhuang, located in northwest China along the Silk Road.

In addition to actual images, prototypes reached Japan in the form of texts and drawings. Numerous model books of iconographically correct renderings were available. They prescribed ideal proportions for depicting the deities of the Buddhist pantheon as well as the standardized hand gestures, body postures, attributes, and animals that help identify the figure; in some cases, the colors are even stipulated.

Early Japanese paintings in Chinese style emulate Tang religious and secular ideas. In fact, aspects of Tang art and culture were assimilated and preserved so well that modern scholars sometimes turned to Japan to affirm elements of certain styles. For example, the fresco depicting Amida's Paradise in the Kondō (Golden Hall) of Hōryuji has always been used as an example of high Tang Buddhist painting. A later

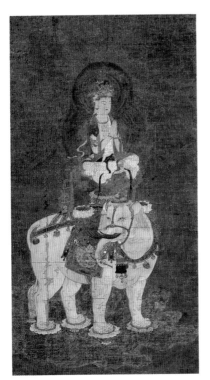

Fugen Bosatsu (Bodhisattva Samantabhadra), no. 35

Extremely thin yet strong, the silk-thread line is closely related to the iron-wire line. The figure is drawn in a line thinner than that for the elephant and lacks shading. The lines curve gradually, turning in only one direction; they convey the quietude of the meditating figure, which seems almost devoid of substance or weight. The elephant, by contrast, conveys weight and movement. The lines of its body are taut, implying volume and fullness. More agitated lines depicting its face, trunk, and neck provide animation.

Sōami, *Li Taibai Viewing a Waterfall*, B62 D11 (not in exhibition)

Sōami's composition follows the Ma Yuan formula of concentrating the action depicted in one corner of the foreground. The middle ground, obscured by mist or open space, gives the impression of infinite extension, and hints of mountains appear in the distance. The most obvious brushwork influence is the profuse use of the axe-cut stroke to define the rocky cliffs. The treatment of the pines with their angular, twisting branches is also representative of the Ma-Xia style. Li Taibai (the Tang poet more commonly known as Li Bo) contemplating the waterfall is equated with man's search for realization of his soul through the mystery of nature, making this work an appropriate subject for Zen meditation.

Japanese Buddhist painting like the *Fugen Bosatsu* (no. 35) still follows the prescribed religious canons and maintains Chinese brush painting techniques, but the subject has taken on uniquely Japanese aesthetic qualities. The depiction of this bodhisattva adheres to descriptions in the Lotus Sutra. Subtle differences in brushwork of lines and colors in the figure and the animal convey their emotional states. The silk-thread line here primarily describes the bodhisattva and the elephant. The application of colors follows the traditional *gongbi* technique. A distinctively Japanese innovation is the use of *kirikane* ("cut gold," that is, thin strips of gold foil) to decorate the bodhisattva's garment. It provides a more sumptuous effect than painting in gold line.

Monochrome ink painting reached Japan in the thirteenth century through Zen (Chinese: Chan) Buddhism, a sect that emphasizes meditation as the way to attain enlightenment. The simplicity of ink painting, empathetic with the Zen approach of transcending appearances, grasps essential qualities of a moment, or of a subject. Zen theories for self-cultivation and salvation were especially appropriate for the discipline of Japan's military class. Therefore ink painting, calligraphy, and the practice of the tea ceremony became part of spiritual exercises for samurai as well as Zen priests.

Works by Chinese Chan masters, some unappreciated in their own country, were highly prized and treasured in Japan. Sesshū Tōyō (1420–1506) and many other Japanese monks made pilgrimages to China seeking religious insights as well as artistic inspiration. Their proto-

types were mostly Southern Song masters, among them Liang Kai and Muqi (act. mid-thirteenth century), and Ma Yuan and Xia Gui. Sesshū in particular was successful in creating powerful images using the brushwork of the Song artists. He formulated three styles based on definitions borrowed from calligraphy: *shin* (standard), *gyō* (running), and *sō* (cursive).

The subject matter of Japanese ink painting includes Chinese-style landscape, particularly famous scenic areas in China such as the Eight Views of the Xiao and Xiang Rivers, and illustrations with Zen-related themes. Sōami's *Li Taibai Viewing a Waterfall* (B62 D11, not in exhibition) is done in the style of Southern Song court painters Ma Yuan and Xia Gui. In his official capacity as keeper of the shogun's Chinese art collection, Sōami (1485?–1525) was in the enviable position of being able to examine and study many of these masterpieces firsthand.

Taming the Ox (no. 36) represents a less formal use of brush and ink. Another diagonal composition, the overall impression is more spontaneous. The overhanging branch at the upper left-hand corner is done in a swift, sketchy manner. To render the hair of both the boy and ox, the artist used a brush so dry that the hair split. The highly agitated brushwork depicting the drapery is the nail-head rat-tail line. Ox herding is a common Zen parable of enlightenment; the mind, like an untamed ox, must be subdued and brought to reason.

In Zen painting the absence of color, the paring down to the essentials, accords with its disregard for traditional form and ritual. The broken-ink and splashed-ink techniques (no. 38), in particular, impart a brevity and immediacy that seem ideally suited to express the suddenness and unexpected quality of enlightenment. From the confused puddles of ink emerge meaning and form. Eccentric persons of unorthodox behavior, who embody the unexpected and the fortuitous, are believed to represent another means of attaining spiritual truth. The Chinese recluses Kanzan (Hanshan) and Jittoku (Shide) as well as other Zen patriarchs were frequent subjects of figure painting (see no. 37).

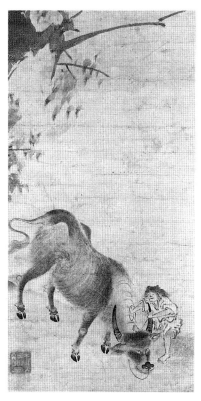

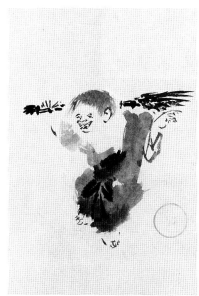

Seal of Kano Tanyū, *Jittoku*, no. 38

Sekkyakushi, *Taming the Ox*, no. 36

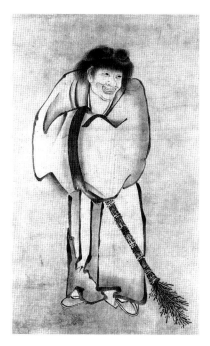

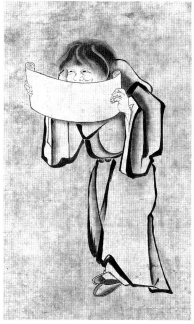

Tōbai, *Kanzan and Jittoku*, no. 37

BUNJINGA AND CHINESE WOODBLOCK PRINTS

During the eighteenth century another trend of Japanese painting emerged, called *nanga* or *bunjinga* (scholar painting). *Nanga*, southern painting, was based on the tradition of scholar painting established in China. The late-Ming critic Dong Qichang (1555–1636) established a concept of the Northern and Southern schools which set up for Chinese painting specific lineages based loosely on styles but more strictly on the moral and cultural standing of the artist. Derived from Chan Buddhism, the Southern school represents the difference between gradual versus sudden and intuitive attainment of spiritual enlightenment. The Northern school refers to the skillful, meticulous works associated with the professional painter, while the Southern school refers to the spontaneous art of the Chinese scholar-painter and gentleman.

The primary sources for *nanga* painters were painting manuals and treatises that provided copies of works by past masters, as well as classifications of all their brush techniques. The manuals include methods of applying dots and texture strokes, explanations of the preparation and use of colors, as well as principles of composing a picture. There are always references to the philosophy of scholar painting as set forth by Dong Qichang.

One shortcoming of relying too heavily on the painting manuals is that the printed image cannot convey all the nuances of brushwork. Although some important artists were involved in the development of designs for the prints for certain editions, in most cases the illustrations were done by secondary artists. Furthermore, with each successive printing the image became farther removed from the original, losing subtle details as the wear of reprinting took its toll on the plates.

The *Mustard Seed Garden Manual of Painting* played an important role in forming the style of brushwork in *nanga* painting. Sakaki Hyakusen's *River Scene in Spring* (no. 31) demonstrates a reliance on the manual, making extensive use of the hemp-fiber stroke, a technique attributed to the Five Dynasties master Dong Yuan. Hyakusen (1698–1753) appears to delight in filling the picture surface with details such as figures and architectural elements. The dense composition is a virtuoso display of his ability to handle brush and ink without falling into total confusion. Gyokudō's *Playing Kin under a Pine Tree* (no. 33) by contrast is sparse and simple. Here man is just a dot in the overwhelming presence of nature. The contours of the mountain and rocks are drawn with an extremely dry brush in light ink, in the severed-band technique associated with the Yuan master Ni Zan, who was said to have used ink as sparingly as gold.

Ike Taiga (1723–1776), another *nanga* painter, was a creative genius who studied thoroughly the methods and examples from these Chinese manuals and treatises but then went on to experiment on his own. In a pair of six-fold screens depicting famous Chinese scenic

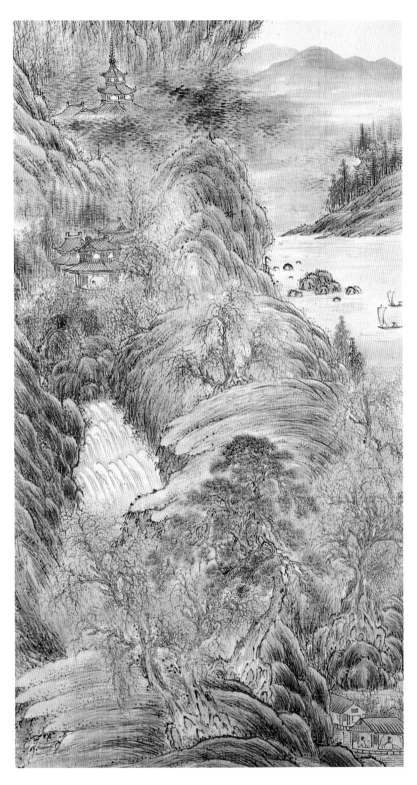

Sakaki Hyakusen, *River Scene in Spring* (detail), no. 31

views (no. 32), the eccentric Taiga employed a myriad of brush styles in a manner totally different from their Chinese prototypes. All the typical forms and combinations are there, including the usual brushwork — cymbidium leaf lines for water and wave; axe-cut strokes, ox-hair strokes (a variant of the hemp-fiber stroke), Mi dots, and raindrop dots for texture; dots in groups of three and five, dots in the form of the character *jie* (𠂤), even-headed dots, and pepper dots for trees and foliage. Taiga's brushstrokes and dots do more than simply describe the features of the mountains, rocks, or trees — they are transformed, energized to convey their own sense of movement.

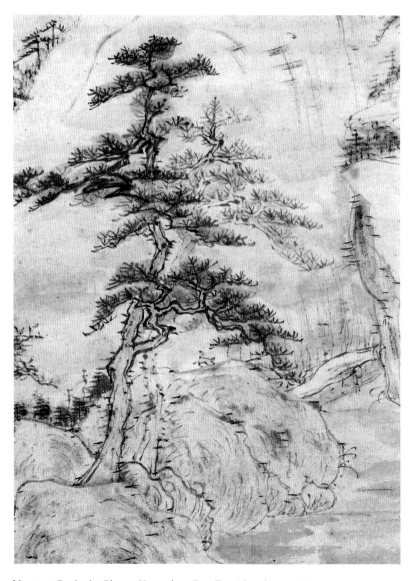

Uragami Gyokudō, *Playing Kin under a Pine Tree* (detail), no. 33

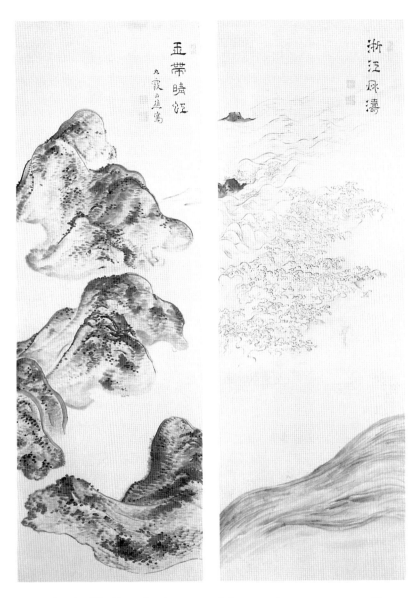

盂帶晴沍

九霞山樵寫

浙江冰濤

Sign and seals of Ike Taiga, *Landscape*, panels from two six-part screens, no. 32

PAINTING AND OTHER DECORATIVE MEDIA

The themes and motifs of painting—legends, literary gatherings both historical and imaginary, landscape, flowers and birds, poetry, calligraphy—all appear in the skillfully executed ceramics, jades, lacquers, and objects in other media that were decorated from very early times in China. Painted lacquers provide some of the earliest examples of Chinese painting; objects from the Warring States (476–221 B.C.) and Han (206 B.C.–A.D. 220) periods convey vivid images of worlds inhabited by men, spirits, and supernatural creatures, and even decorated neolithic pottery exhibits sensitivity and skill in brushwork.

The production of fine art objects in China, however, for the most part differed greatly from the making of paintings and calligraphy. Most notably, the production of ceramic and jade objects was closely supervised, highly specialized, and subdivided into discrete tasks. A potter might do nothing more than make foot rings or apply handles; a jade carver might have the task of roughing out a certain shape, or of painstakingly polishing the object that numerous others before him had worked to create in a great many steps. The potter did not paint; the painter did not throw pots; even the application of specific colors might be the work of individual specialists.

Little is mentioned of designers who composed patterns for ceramic wares; however, records show factory orders from patrons, both imperial and commercial (including European, Japanese, and Southeast Asian markets), specifying subjects, themes, and sometimes even colors decorating pieces to be produced. Although many works indicate high levels of skill in painting as well as great originality in design, the evidence indicates that these craftsmen were never considered artists, let alone painters. Even in the imperial workshops of the Ming and Qing periods, which were run by court-appointed officials with titled positions, craftsmen were treated as laborers and worked under harsh conditions. One poignant account relates that Jesuit artists, forced to work in the Qing imperial workshop because of their knowledge of Western enamel techniques, deliberately painted poorly so they could be released from the arduous task. With the exception of Yixing ware, for which there existed a close relationship between potters and their scholar-patrons, none of the works was signed, and there are no records of known potters or designers.

Pictorial images on ceramics and lacquers reflect prevalent contemporary styles and subjects of painting. Song dynasty stoneware from Cizhou (no. 43) is decorated with expressive and spontaneous ink painting in the *xieyi* manner that was favored by scholar-gentlemen. The bodies of these wares were covered with a white slip to provide a reflective painting surface, like that of paper. Lines of poetry are often inscribed with the pictures; since most were copied by illiterate craftsmen, one often finds words missing or written incorrectly.

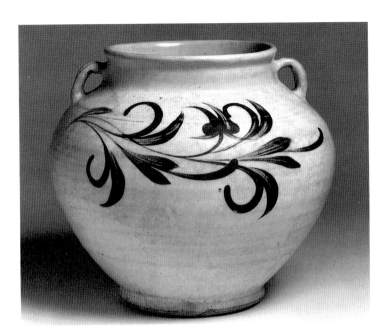

Jar with floral design in *xieyi* style, no. 43

The simple sprig ornamenting this jar was executed swiftly, with absolute control of the brush. Its pressure and speed vary from light to heavy, fast to slow. It is even possible to see where the hair of the brush has split within a stroke.

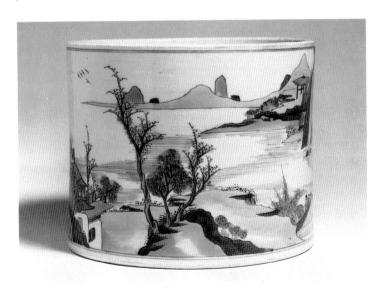

Brush holder with landscape scene, no. 46

The landscape composition is filled with poetic allusions. The fisherman in a boat, lower right, evokes the idyllic life, a retreat from social responsibilities and official duties. The simple grass hut in the distance, a common motif in the works of the Yuan recluse Ni Zan, reinforces the concept of retreat to the beauty and grandeur of nature. Ni was known to have traveled through the streams and rivers of Jiangsu by boat during his later years.

Porcelains of the Ming and Qing periods represent some of the most exquisitely painted images in monochrome and colors. A brush holder for the scholar's table (no. 46) is decorated in underglaze blue with a landscape executed in the manner of literati ink painting. Its intimate quality seems appropriate for a small album leaf for a special friend, or a handscroll—something personal to be examined closely. The artist has drawn the composition in clearly articulated lines. Graduated shades of blue effectively emulate the subtle washes seen in ink paintings. In a few places, lines and dots are used to define texture and suggest vegetation.

A bowl with flattened rim decorated in underglaze blue depicts a literary gathering of scholars in a garden setting enjoying the Four Accomplishments of qin, chess, calligraphy, and painting (no. 48, not illustrated). Su Dongpo's "Ode to the Red Cliff," a widely acclaimed poem, has long been a subject for calligraphy and painting. Both the poem and its corresponding scene occupy opposite sides of a tall cylindrical vase (no. 50). The painting is done in a precise, meticulous manner. Fine lines delineate ripples on the water, in contrast to the brush holder (no. 45), on which the water's presence is suggested with just a few lines. Colors tend to be bright and heavy, in strong mineral blue and green. Long, relaxed gold lines define the texture of the central cliff directly in front of the scholars. The gilding was perhaps a way of suggesting moonlight reflected against the surface of the steep precipice. The small disc and star diagrams in the sky provide clues that Su's outing with his two friends occurred at night.

Another vase depicts the Tang emperor Minghuang's visit to the Lunar Palace (no. 49). This is also done in the gongbi style with precise lines, meticulous details, and bright colors. On the neck of the vase is the Taoist immortal Zhang Xian, the Protector of Children, who is in the process of shooting the Heavenly Dog, the celestial star that causes sons to be short-lived. In contrast to the ladies below, whose features and draperies are done in fine, even lines, Zhang is conceived in a dramatic manner. The animation of his expressive face is reinforced by drapery lines that are more angular and articulated, seen in the sleeves in particular, which are drawn with nail-head rat-tail lines. The lady holding the white rabbit is Chang'o, who resides in the moon palace. Directly behind her and her attendants is a painted screen with crashing waves and strange mountain peaks. The balustrade in front of her contains marble slabs with dark markings that resemble landscape paintings. Scholars treasured such "marble paintings," according them special places in their studios and estates. On the other side the emperor Minghuang and his entourage approach the moon palace.

Bird and flower painting is prominent in later ceramics. The decoration of rocks, narcissus, lingzhi fungus, and heavenly bamboo on a finely painted small plate symbolizes wishes for a long life (no. 52).

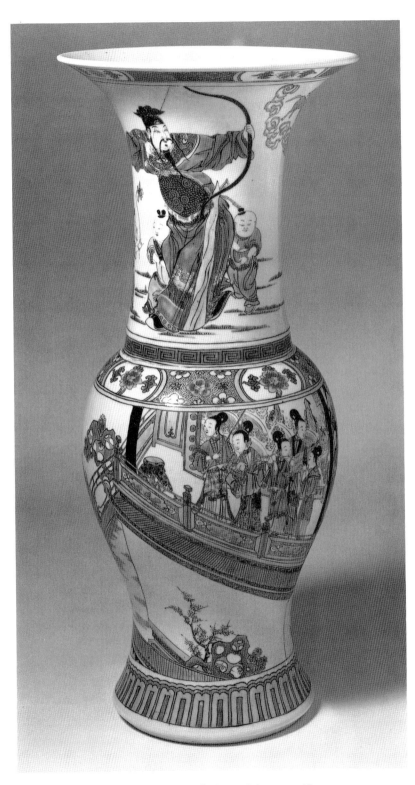

Vase with scene of Minghuang visiting the Lunar Palace, no. 49

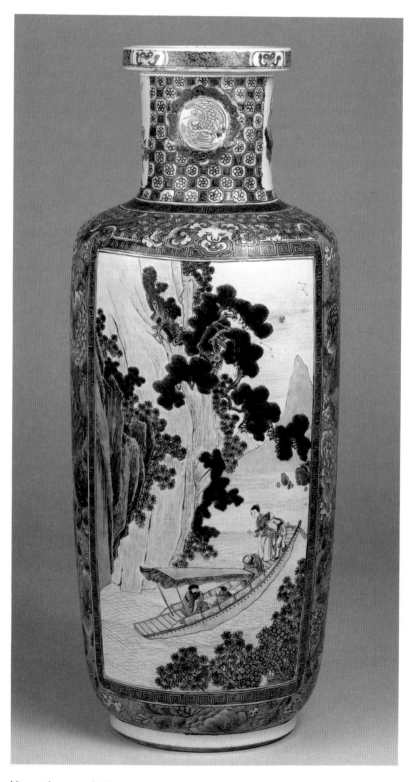

Vase with scene of "The Red Cliff," no. 50

The leaves of the narcissus and the stem and foliage of the heavenly bamboo come close to the boneless style of painting, with its subtle and diffused colors. The flowers, done in the outline-and-fill technique, convey grace and charm. The sensitive treatment of the Taihu rocks (a kind of strangely shaped rock popular in garden design) is accomplished through careful application of lines and layers of pale washes. Another plate decorated with prunus blossoms and chrysanthemums is done entirely in the careful *gongbi* style (no. 54). The forms are clearly outlined with heavier applications of colors.

A close relation between painting and carving, which can be traced to early times, exists in China. Carving on stones has long been a method of preserving painting and calligraphy. Such carvings are records of works and styles that have vanished with the perishable materials upon which they were originally written or painted. Ink rubbings taken from these carvings subsequently served as models for later students of the art. In some ways this process resembles block printing and might have been the impetus or predecessor for it.

Striking similarities may exist between a painting or calligraphy and its copy on stone. Relief carvings found in early shrines and tombs have strong linear qualities directly relating to painting; in the Tang dynasty cave temples at Dunhuang, visual impressions created by the

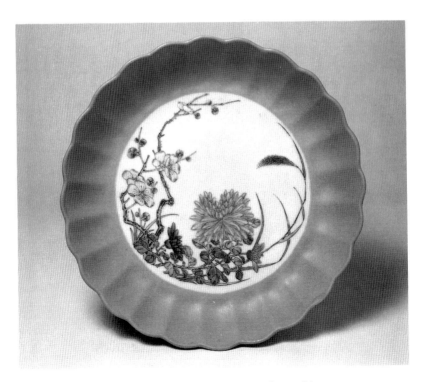

Saucer with flowering plum and chrysanthemum motifs, no. 54

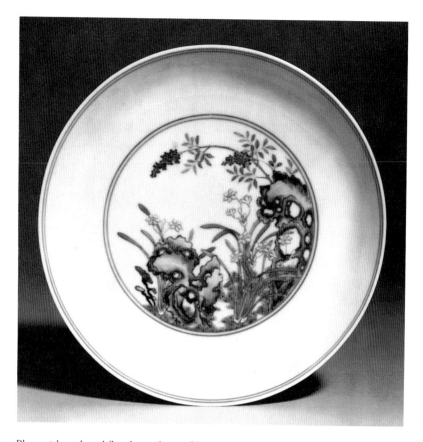

Plate with rock and floral motifs, no. 52

painted and sculpted images are so similar that it is difficult to discern where one type of image ends and the other begins.

Sometimes the calligraphy or painting is copied onto materials more precious than stone or wood. A jade tablet (B60 J141, not in exhibition) carved in 1746 is an engraved and gold-painted replica of a copy of Wang Xizhi's (309–ca. 365) *Kuaixue shiqing tie* (Letter Written after a Snow Flurry). Wang was admired as the supreme master of calligraphy, and his works have been immortalized in countless forms and manners.

The composition of a painting by the Ming dynasty artist Qiu Ying is reproduced in a carving of lapis lazuli in the shape of a mountain for the scholar's table (no. 62). It also bears an inscription in the hand of the Qianlong emperor. The long tradition of translating painted designs into carving created a natural tendency to borrow compositional elements from painting and to retain some of its aesthetic qualities. Images in low relief imitate the lines and texture strokes from painting.

Jade tablet, B60 J141 (not in exhibition)

This tablet, carved in 1746, included reproductions of the seals and comments that exist on the original calligraphy in the Qianlong emperor's collection. At upper left, an imperial seal is applied over the character *shen* (divine). The artist conveyed the sense of modulating and dynamic brushwork in the character, yet still preserved the even, hard-edged impression of the seal that was originally carved in stone.

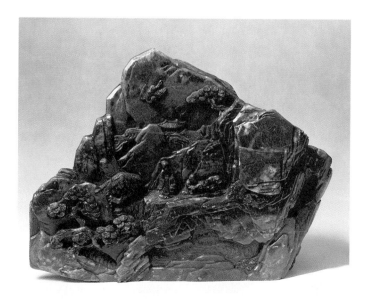

Figures in a landscape after a Qiu Ying painting, no. 62
(see also back cover)

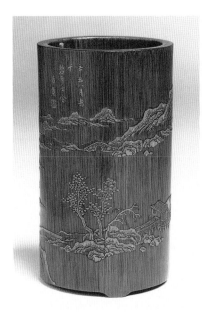

Brush holder with landscape scene,
signed Xihuang, no. 56

Bamboo carving, particularly for brush
holders and wrist rests, was strongly
influenced by motifs from woodblock
prints. Bamboo carvers attempted to
achieve gradations of tone similar in
effect to the five-color theory of ink
painting (see p. 8). During the Ming
dynasty, bamboo artists perfected *liuqing*
(retaining the green, or retaining the
skin of the bamboo), a method of scrap-
ing the bamboo skin to varying depths,
enabling the artist to reveal a great vari-
ety of tones.

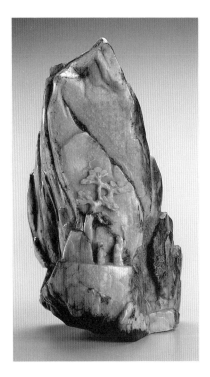

Figures in a landscape, no. 60

In the sixteenth century, scholars themselves began to carve bamboo in their leisure, just as many carved their own seals. Unlike ceramics or jade produced by unknown artisans, many of these bamboo carvings are signed, and we have information about the artists. Jin Yuanyu of the Jiaqing period (1796–1820) wrote the *Zhuren lu* (Biographies of Bamboo Artists). Some of these artists were also accomplished in poetry, painting, calligraphy, and seal carving. Zhang Xihuang (no. 56), a specialist in the *liuqing* technique, used it to achieve a gradation of tones similar to those of ink painting.

Artists working with stone or jade often used the natural markings and irregularities of the material to suggest brushwork. A jade mountain (no. 60) with an imperial transcription of a poem by the Ming scholar-painter Wen Zhengming makes use of the black patches in the stone to imitate lines in a painting. They form outlines for edges of the cliff and rocks. Lighter and darker spots suggest the effect of layered ink washes. Small specks and fine lines resemble dots and texture strokes. The poem, making a reference to the evocative power of a painting to recall the majestic sight and sounds of a waterfall in a snow-covered mountain setting, completes the literati ideal of the Three Perfections—the incorporation of poetry, calligraphy, and painting within a single work.

NOTES

1. Funeral banners uncovered from Warring States and Han dynasty tombs are some of the earliest known examples of paintings on silk. The banner from the Mawangdui tombs (excavated in the 1970s) used mineral and vegetal pigments. Cave temples at Dunhuang in the northwest contain numerous Buddhist images, paintings, and manuscripts.

2. Yu Feian, *Chinese Painting Colors: Studies of Their Preparation and Application in Traditional and Modern Times*, trans. Jerome Silbergeld and Amy McNair (Seattle: University of Washington Press, 1988), p. 22. For the original Chinese text, see *Zhongguohua Yanse di yanjiu* (Shanghai: People's Art Publisher, 1955), p. 16.

3. Yu Feian, *Chinese Painting Colors*, p. 36.

CHECKLIST OF THE EXHIBITION

An asterisk indicates works exhibited in San Francisco only. Unless otherwise noted, all objects are part of The Avery Brundage Collection, Asian Art Museum of San Francisco.

CHINA

Landscape

1. TRAVELERS IN A MOUNTAIN PASS AFTER HEAVY SNOW
Attributed to Xie Shichen (1488–ca. 1567)
Ming dynasty
Hanging scroll, ink and colors on paper
H: 275.4 cm, W: 100.7 cm
Gift of the Asian Art Museum Foundation, B67 D9

2. THE STONE TABLE GARDEN
Sun Kehong (1532–1610)
Ming dynasty, dated 1572
Handscroll, ink and colors on paper
H: 31.3 cm, L: 369.9 cm
Gift of Mrs. Mary Gary Harrison, B69 D52

* 3. LANDSCAPE AFTER WANG WEI'S "WANGCHUAN PICTURE"
Song Xu (1525–ca. 1605)
Ming dynasty, dated 1574
Handscroll, ink and colors on paper
H: 31.4 cm, L: 887.5 cm
Gift of the Asian Art Museum Foundation, B67 D2

4. LANDSCAPE
Li Liufang (1575–1629)
Ming dynasty, dated 1620
Fan painting, ink on gold-flecked paper
H: 18.3 cm, W: 51.5 cm
Gift of Tina and Alexander Coler, B79 D18

5. WHIRLING SNOW ON THE RIVERBANK
Lan Ying (1585–after 1660)
Ming dynasty, dated 1639
Hanging scroll, ink on silk
H: 188 cm, W: 92.7 cm
Gift of Austin Hills, B69 D56

* 6. FANTASTIC LANDSCAPE
Fan Qi (1616–ca. 1695)
Qing dynasty, dated 1645
Handscroll, ink and colors on paper
H: 30.9 cm, L: 407 cm
B66 D19

7. LANDSCAPE
Xiang Shengmo (1597–1658)
Ming dynasty, dated 1656
Set of 10 album leaves, ink and colors on paper
H: 30.7 cm, W: 22.8 cm
Gift of the Asian Art Museum Foundation, B74 D4

8. LANDSCAPE
Cha Shibiao (1615–1698)
Qing dynasty, dated 1686
Hanging scroll, ink on paper
H: 127.2 cm, W: 52.1 cm
Gift from the Society for Asian Art, B69 D41

9. LANDSCAPE
Zhuang Jiongsheng (1627–1679)
Qing dynasty
Handscroll, ink and colors on paper
H: 20.8 cm, L: 538.4 cm
B68 D2

*10. THE HERMITAGE
Chang Dai-chien (Zhang Daiqian, 1899–1983)
Dated 1930
Hanging scroll, ink and colors on silk
H: 130.9 cm, W: 64.1 cm
B60 D78

11. IMAGE OF FLEETING TIME
Liu Kuo-sung (Liu Guosong, b. 1932)
Dated 1965
Handscroll, ink and acrylic on paper
W: 54.9 cm, L: 600.5 cm
Gift of the Asian Art Museum Foundation, B68 D17

Figure Painting

12. SCHOLAR IN A LANDSCAPE
Tang Yin (1470–1523)
Ming dynasty
Fan painting, ink on gold-flecked paper
H: 19.6 cm, W: 56.5 cm
Gift of Mr. and Mrs. Walter Shorenstein, B81 D37

13. PARTING UNDER A WILLOW TREE
Qiu Ying (ca. 1494–ca. 1552)
Ming dynasty
Fan painting, ink and colors on gold-flecked paper
H: 17.4 cm, W: 51.5 cm
Asian Art Museum Acquisition Fund, B79 D5b

*14. RUAN XIU IN A LANDSCAPE
Chen Hongshou (1598–1652)
Late Ming–early Qing dynasty
Hanging scroll, ink and colors on silk
H: 124.5 cm, W: 49.5 cm
Asian Art Museum Acquisition Fund,
B79 D8

15. ZHONG KUI (THE DEMON
QUELLER) ON A MULE
Pu Ru (1896–1963)
Hanging scroll, ink and colors on paper
H: 91.5 cm, W: 38 cm
Purchased with funds from the John W.
and Christine C. Barr Gift Fund,
B82 D2

*16. SCHOLAR AND PINE TREE
Chang Dai-chien (1899–1983)
Dated 1948
Hanging scroll, ink and colors on paper
H: 103.4 cm, W: 33.9 cm
B60 D75

Flowers

*17. FLOWERING PLANTS AND
TREES
Chen Chun (1483–1544)
Ming dynasty
Handscroll, ink and colors on paper
H: 24.8 cm, W: 206 cm
Gift of J. P. Dubosc, B70 D4

18. INK FLOWERS
Xue Wu (ca. 1564–ca. 1637)
Ming dynasty, dated 1615
Handscroll, ink on paper
H: 26 cm, L: 626.5 cm
Gift of the Asian Art Museum
Foundation, B66 D22

19. INK BAMBOO
Yang Jin (1644–after 1726)
Qing dynasty
Hanging scroll, ink on paper
H: 116.1 cm, W: 28.1 cm
Gift of Gryffyd and Janet Partridge,
1991.240

20. TWELVE FLOWER PAINTINGS
Yun Bing (act. ca. 1670–1710)
Qing dynasty
Set of 12 album leaves, ink and colors
on silk
H: 40.9 cm, W: 33.2 cm
B65 D49a–l

21. GOURDS
Qi Baishi (1863–1957)
Hanging scroll, ink and colors on paper
H: 73.3 cm, W: 32.5 cm
B69 D15

22. WHITE LOTUS
Chang Dai-chien (1899–1983)
Dated 1948
Hanging scroll, ink and colors on paper
H: 142.5 cm, W: 70 cm
Gift of Rudolph Schaeffer from his art
collection, B87 D1

Birds and Animals

23. SNOWY EGRET UNDER A TREE
BY A RIVER
Zhou Zhimian (1577–1609)
Ming dynasty
Fan painting, ink and colors on gold-
flecked paper
H: 15.1 cm, W: 44.6 cm
Gift of Marjorie Bissinger Seller,
B79 D24

24. TIGER
Gao Qipei (ca. 1672–1734)
Qing dynasty
Hanging scroll, ink and colors on paper
H: 137.7 cm, W: 73 cm
B60 D15

25. GEESE AMONG REEDS
Attributed to Huang Shen (1687–
ca. 1768)
Qing dynasty
Hanging scroll, ink and colors on paper
H: 102.2 cm, W: 135 cm
Gift of the Asian Art Museum
Foundation, B74 D1

26. IMPRESSION OF SAN
FRANCISCO ZOO
Wang Yani (b. 1975)
Ink and colors on paper
H: 64.1 cm, W: 178.7 cm
Gift of the artist, 1990.10

Calligraphy

27. SONG OF THE FISHERMAN
Chen Xianzhang (1428–1500)
Ming dynasty
Hanging scroll, ink on paper
H: 127.2 cm, W: 51.4 cm
Gift of the Asian Art Museum
Foundation, B68 D6

TIBET

Figure Painting

*28. YAMA
18th century
Thangka, ink and colors on cotton
H: 67.9 cm, W: 43.7 cm
B60 D25

29. SITASAMVARA
19th century
Thangka, ink and colors on cotton
H: 45.4 cm, W: 31.1 cm
Gift of Albert Bender, B78 D3

Calligraphy

*30. EDICT FROM A DALAI LAMA
Dated 1723 or 1783
Ink on silk
L: 92.3 cm, W: 62.8 cm
Gift of Margaret Polak, Mr. and Mrs.
Johnson S. Bogart, and Connoisseur's
Council, 1989.31

JAPAN

Landscape

31. RIVER SCENE IN SPRING
Sakaki Hyakusen (1698–1753)
Edo period
Hanging scroll, ink and colors on paper
H: 130.8 cm, W: 53.3 cm
Gift of Gloria Hahn (Kim Ronyoung),
author of *Clay Walls*, 1990.9.2

32. LANDSCAPE
Sign and seals of Ike Taiga (1723–1776)
Edo period
Pair of 6-fold screens, ink and colors on
paper
Each panel: H: 170.2 cm, W: 63.5 cm
Gift of the Asian Art Museum
Foundation, B65 D50, D51

33. PLAYING *KIN* UNDER A PINE
TREE
Uragami Gyokudō (1745–1820)
Edo period
Hanging scroll, ink and colors on paper
H: 28.6 cm, W: 23.5 cm
Gift of the Ney Wolfskill Fund,
B69 D49

34. PURE VIEW OF STREAM AND
HILLS
Takahashi Sōhei (1803–1834)
Late Edo period, dated 1832
Hanging scroll, ink on silk
H: 118.4 cm, W: 43 cm
Gift of the Asian Art Museum
Foundation, B76 D2

Figure Painting

35. FUGEN BOSATSU (Bodhisattva
Samantabhadra)
Early Kamakura period, 13th century
Hanging scroll, ink, colors, and gold on
silk
H: 71.5 cm, W: 36.8 cm
B66 D2

36. TAMING THE OX
Sekkyakushi (act. early 15th century)
Muromachi period
Hanging scroll, ink on paper
H: 47.8 cm, W: 23.2 cm
Gift of the Ney Wolfskill Fund,
B69 D46

37. KANZAN AND JITTOKU
Tōbai (act. 16th century)
Muromachi period
Pair of hanging scrolls, ink on paper
H: 92.7 cm, W: 43.6 cm
B60 D39+ a, b

38. JITTOKU
Seal of Kano Tanyū (1602–1674)
Edo period
Hanging scroll, ink on paper
H: 39.5 cm, W: 28.1 cm
B65 D11

*39. TŌHŌSAKU
Attributed to Maruyama Ōkyo (1733–
1795)
Hanging scroll, ink and colors on paper
H: 37 cm, W: 43.6 cm
B60 D16

Birds and Flowers

40. BAMBOO
Gyokuran (1728?–1784)
Edo period
Hanging scroll, ink on paper
H: 111 cm, W: 26.7 cm
B65 D45

41. MONKEYS
Mori Sosen (1749–1821)
Edo period
Hanging scroll, ink and colors on silk
H: 42.8 cm, W: 73.7 cm
B64 D2

42. HERONS AND REEDS
Yamamoto Baiitsu (1783–1856)
Edo period
Hanging scroll, ink and colors on silk
H: 134.6 cm, W: 42.5 cm
B65 D14

CHINESE CERAMICS

43. JAR WITH FLORAL DESIGN IN
XIEYI STYLE
Song dynasty (960–1279)
Painted stoneware
H: 22.2 cm, W: 23.5 cm,
DIAM: 22.9 cm
B60 P1+

*44. DISH WITH POMEGRANATE
SPRIG
Ming dynasty, Xuande reign mark
(1426–1435)
Jingdezhen ware, blue-and-white
porcelain
H: 5.4 cm, DIAM: 29.7 cm
The Roy C. Leventritt Collection,
B69 P231

45. DISH WITH THE FIGURE OF
HANSHAN
Ming dynasty, Tianqi period (1621–
1627)
Ko-sometsuke ware, blue-and-white
porcelain
H: 3.1 cm, DIAM: 21.3 cm
The Effie B. Allison Collection,
gift of Mrs. Jeanette V. West and
Mrs. Betty V. Gewald, B81 P7

46. BRUSH HOLDER WITH
LANDSCAPE SCENE
Qing dynasty, Kangxi period (1662–
1722)
Blue-and-white porcelain
H: 14.5 cm, W: 18.3 cm
B60 P118

*47. TEAPOT WITH LANDSCAPE
SCENE
Qing dynasty, Kangxi period (1662–
1722)
Blue-and-white porcelain
H: 11 cm, W: 16.5 cm
B60 P1730

*48. BOWL WITH SCENE OF
LITERARY GATHERING
Qing dynasty, Kangxi period (1662–
1722)
Blue-and-white porcelain
H: 9.5 cm, DIAM: 19.6 cm
The Roy C. Leventritt Collection,
B69 P1421

49. VASE WITH SCENE OF
MINGHUANG VISITING THE
LUNAR PALACE
Qing dynasty, Kangxi period (1662–
1722)
Porcelain with famille verte enamels
H: 48.2 cm, DIAM: 22.6 cm
B60 P53

50. VASE WITH SCENE OF "THE
RED CLIFF"
Qing dynasty, Kangxi period (1662–
1722)
Porcelain with famille verte enamels
H: 46.7 cm, W: 14 cm
B60 P54

*51. VASE WITH FIGURAL SCENE
Qing dynasty, Kangxi period (1662–
1722)
Porcelain with famille verte enamels
H: 45.7 cm, DIAM: 17.8 cm
B60 P61

52. PLATE WITH ROCK AND
FLORAL MOTIFS
Qing dynasty, Yongzheng period (1723–
1735)
Porcelain with famille rose enamels
H: 3.8 cm, DIAM: 20.9 cm
B60 P192

*53. BOWL WITH SCENE OF
MANDARIN DUCKS IN A POND
Qing dynasty, Yongzheng period (1723–
1735)
Porcelain with underglaze blue and
overglaze enamels
H: 4.1 cm, DIAM: 17.3 cm
B60 P1426

54. SAUCER WITH FLOWERING
PLUM AND CHRYSANTHEMUM
MOTIFS
Qing dynasty, Yongzheng period (1723–
1735)
Porcelain with famille rose enamels
H: 3 cm, DIAM: 16.2 cm
B60 P1433

*55. BRUSH HOLDER WITH ROCK
AND FLOWER PANELS AND
CALLIGRAPHY
Qing dynasty, Qianlong period (1736–
1795)
Porcelain with famille rose enamels
H: 8.2 cm, W: 4.9 cm
B60 P2342

OTHER MEDIA

*56. BRUSH HOLDER WITH
LANDSCAPE SCENE
Signed Xihuang (Zhang Xihuang)
Qing dynasty, dated 1661
Bamboo
H: 10.1 cm, DIAM: 5.5 cm
B60 M356

*57. BRUSH HOLDER WITH
LANDSCAPE SCENE
Signed Zhang Xihuang
Qing dynasty, late 17th century
Bamboo
H: 10.7 cm, DIAM: 5.8 cm
B62 M87

*58. BRUSH HOLDER WITH SCENE
OF FIGURES IN A LANDSCAPE
Late Ming–early Qing dynasty,
17th century
Yellow and red soapstone
H: 16.3 cm, DIAM: 14.6 cm
B62 J3

*59. LOHAN IN A LANDSCAPE
Qing dynasty, 18th century
Jade
H: 28.1 cm, W: 13.7 cm
B60 J282

*60. FIGURES IN A LANDSCAPE
Inscribed with a poem by Wen
Zhengming
Qing dynasty, 18th century
Jade
H: 24.6 cm, W: 12.2 cm
B60 J265

*61. FIGURES IN A LANDSCAPE
Qing dynasty, 18th century
Jade
H: 18.5 cm, W: 12.1 cm
B60 J460

*62. FIGURES IN A LANDSCAPE
AFTER A QIU YING PAINTING
Qing dynasty, 18th century
Lapis lazuli
H: 23.5 cm, W: 33.5 cm
B60 J31

BIBLIOGRAPHY

Acker, William. *Some T'ang and Pre-T'ang Texts on Chinese Painting.* Leyden: E. J. Brill, 1974.

Barnhart, Richard M. *Peach Blossom Spring: Gardens and Flowers in Chinese Painting.* New York: Metropolitan Museum of Art, 1983.

Bartholomew, Terese Tse. *The Hundred Flowers: Botanical Motifs in Chinese Art.* San Francisco: Asian Art Museum of San Francisco, 1985.

————. *Myths and Rebuses in Chinese Art.* San Francisco: Asian Art Museum of San Francisco, 1988.

Bush, Susan. *Early Chinese Texts on Painting.* Cambridge, Mass.: Harvard University Press for Harvard-Yenching Institute, 1985.

Bush, Susan, and Hsio-yen Shih. *The Chinese Literati on Painting.* Harvard-Yenching Institute Studies, no. 27. Cambridge, Mass.: Harvard University Press, 1971.

Cahill, James. *Scholar Painters of Japan: The Nanga School.* New York: Asia Society, 1972.

Ch'en, Chih-mai. *Chinese Calligraphers and Their Art.* Carlton South, Victoria: Melbourne University Press, 1966.

Fu, Shen C.Y., with Marilyn W. Fu, Mary G. Neill, and Mary Jane Clark. *Traces of the Brush: Studies in Chinese Calligraphy.* New Haven: Yale University Press, 1977.

Goepper, Roger. *The Essence of Chinese Painting.* London: Percy Lund, Humphries & Co., 1963.

Jackson, David, and Janice Jackson. *Tibetan Thangka Painting: Methods and Materials.* Boulder, Colo.: Shambhala Publications, 1984.

Kakudo, Yoshiko. *The Art of Japan: Masterworks in the Asian Art Museum of San Francisco.* San Francisco: Asian Art Museum of San Francisco and Chronicle Books, 1991.

Kan, Diana. *The How and Why of Chinese Painting.* New York: Litton Educational Publishing, Van Nostrand Reinhold, 1974.

Ledderose, Lothar. *Mi Fu and the Classical Tradition of Chinese Calligraphy.* Princeton: Princeton University Press, 1979.

March, Benjamin. *Some Technical Terms of Chinese Painting.* Baltimore, Md.: Waverly Press, 1935.

Miyajima, Shin'ichi, and Yasuhiro Satō. *Japanese Ink Painting.* Ed. George Kuwayama; trans. Karen L. Brock and Christine Guth Kanda. Los Angeles: Los Angeles County Museum of Art, 1985.

Silbergeld, Jerome. *Chinese Painting Style: Media, Methods, and Principles of Form.* Seattle: University of Washington Press, 1982.

Siren, Osvald, tr. and ed. *The Chinese on the Art of Painting.* Beijing: Henri Vetch, 1936.

Sullivan, Michael. *The Three Perfections: Chinese Painting, Poetry, and Calligraphy.* London: Thames and Hudson, 1974.

Van Briessen, Fritz. *The Way of the Brush: Painting Techniques of China and Japan.* Rutland, Vt.: Charles E. Tuttle, 1962.

Wang, Gai, et al. *The Mustard Seed Garden Manual of Painting.* Trans. Mai-mai Sze. Princeton: Princeton University Press, 1963.

Wang, Shixiang, and Weng Wan-go. *Bamboo Carving of China.* New York: China House Gallery, 1983.

Yu, Feian. *Chinese Painting Colors: Studies of Their Preparation and Application in Traditional and Modern Times.* Trans. Jerome Silbergeld and Amy McNair. Seattle: University of Washington Press, 1988.